# Why are you Shivering?

*A Collection of Monologues & Exploration of Expression*

Edited by Robert Wallace

Why are you Shivering?

Published by
Lulu
www.lulu.com

Copyright © 2012 Robert Wallace. All rights reserved.

**The stories in these monologues are works of fiction. Names of characters, places, and incidents are the products of the author's imaginations or are used fictitiously. Any resemblance to actual events, locales, or persons living or dead, is entirely coincidental.**

**Acknowledgements can be found on page 53.**

Caution: Professionals and amateurs are hereby warned that the monologues represented in this book are subject to a royalty. They are fully protected under the copyright laws of the United States of America, and all countries covered by the International copyright Union. (Including the dominion of Canada and the rest of the British Commonwealth), and of all countries covered by the Pan-American Copyright Convention and the Universal Copyright Convention, and of all countries with which the United states has reciprocal copyright relations. All rights, including professional, amateur, motion picture, recitation, lecturing, public reading, radio broadcasting, television, video or sound taping, all other forms of mechanical or electronic reproductions and photocopying are strictly reserved. Particular emphasis is placed on the question of readings and all uses of these plays by educational institutions, permission for which must be secured from the authors in writing.

Published in the United States of America
ISBN: 978-1-105-72456-5
Manufactured in the United States of America

# INTRODUCTION

This collection of monologues was developed for a few reasons.

One, actors always need monologues. They need words to say that are crunchy and move them from one place to another, that create a framework that holds emotion and reveals a glimpse of who is inside. Words on paper, when together in the right sequence can reveal character. People are like poetry, they happen between the lines. But, the words need to be there in surprising and varied combination, so the actor can fill them, work against them, give them further life.

Two. Writers need to feel their work is real. The ephemeral nature of writing needs to be concretized for the writer, especially the new and emerging writer. The idea is caught, it forms into words and the writer places it on paper. For playwrights, the next step is to hear those words spoken by actors who give them further dimension and resonance. And, the step after that is to see them published, printed and somehow anonymous. When words are given away to the world they grow up and are responsible for their own fate. It's kind of like sending your kid off to college.

And three, Robert Wallace, our editor, wanted to see how he could serve as a theatre artist in the collection and presentation of these monologues from the Spring

2012 group of playwrights at California State University Fullerton. The editor shapes our view, takes responsibility for the importance of their project and for the way in which we receive the work.

So, the class proudly presents themselves, their words and their stamp on today.

It is a great privilege and pleasure to crank the volume on these writers' voices. Supporting the cracking open of new ideas makes my life rich and surprising.

Thanks for being part of the value of art.

Susan Merson,

Playwright and teacher

California State University, Fullerton.

## A WORD FROM THE EDITOR

For those of you who are opening this book for the first time, and wondering what to expect, allow me to give you an idea of what these pages contain. In each and every one of these pages are the words thought up by an individual with a heart and a need to express themselves, but without the means. The need for expression is an utterly human instinct. It lies in the core of our souls. Some say it is one of the parts that separate us from other creatures; this basic desire to look at the world and then scream at the top of our lungs "THIS IS WHAT I SEE! THIS IS WHAT I FEEL! THIS IS HOW THE WORLD IS!" Yet, what is the purpose of the spoken word if there is no one there to hear it? As you flip through these pages and read the expressions of each author, you will find an eclectic assortment of points of views. As well as a variety of emotional palettes. Some are filled with awe, some with sorrow, and some with utter joy.

Like a letter in a bottle thrown out to sea, a published text is the author's letter to the anonymous reader. Art is a form of expression, but like a bridge over water, art has two sides to it. A bridge connects one shore to the next. With only one piece of land a bridge would not fulfill its purpose, it would not be complete. Art also needs two parts, a creator and an observer. What is the point if you were to build a sculpture in your mind? Perhaps you see all of the miniscule details in your head all of the curves and edges. But if there were no one else there to see the artwork, it would lose its power. The beauty would be

wasted on one person, and so it is the duty of each artist to share their art with each person.

Playwriting is a beautiful art form because not only is it an artistic expression for the author, but it serves as a foundation and tool for artistic expression for many other artists in collaboration. This includes acting, directing, scenery, lighting and sound, and costuming makeup. Many artists are involved in a play, and it is the beauty of the script that brings them together. So this published text is a collaborative work that is a celebration in the development and publication of playwriting. Its purpose is to serve as a resource for actors searching for material to work with, as well as provide insight into the developmental process of playwriting. Each of these playwrights has shared the same class together in the same university, and each person had the same writing prompt: "Why are you shivering?" It is an intentionally open ended question that allows the writers to explore and create.

So with each writer, they begin with the same title, and inspiration: "Why are you shivering?" and that single line launches them into a world of ideas from which they can create a monologue from. So every monologue is completely unique from the one before it. In this aspect, this book is truly a celebration of creativity. It is also Important to note that in each monologue, the author strove to contain the ten elements of a great monologue as taught by Gabriel Davis.

If you are an actor, we encourage and implore you to use these pieces in your auditions. Also, note that these monologues are not entirely or necessarily

gender specific. It may be found that the majority of these works were written a character of the same gender as the author. This can be found because the authors were encouraged to create something that they themselves would want to perform.

    We hope that you are as inspired by these works as we were in creating them. As the editor, special thanks go out to all of the playwrights who contributed to this book, as well as to Susan Merson who helped birth this idea.

Robert Wallace

## INTERVIEWS

During the building of this book, it was important that as the editor, I spoke with the playwrights to have some input on this book. I spoke with fellow playwright Marc Assad, and this is the interview as follows:

**Could you give us a little information about your own writing process?**

I get completely nude... no **(he laughs)** honestly I don't prepare to write, I just write. I don't like to have anything else to worry about. But when I sit down and say "I'm going to write" mostly it cuz I've been hearing the characters in my head.

**So what you're saying is you're schizophrenic.**

Well, kinda yea, I'll be hearing them saying things and I just try to jot them down on the whiteboard here and there, throughout the week. And then when I get to sit down and actually write it down, that's like the dessert.

I just drop whatever the conversation is and go as far as it can go, and I'm just trying to figure out what the play is about. It could just be one characters monologue, or a few scenes. After that happens, then I try to write down the theme, what the characters want, and the outline

**So let's talk about the exercises. Do you depend on them? Are they helpful?**

Yes they're absolutely helpful. When I put down the character outlines it shows the shape, but really the most important thing is the theme. Figuring out what the frame of the themes is for me.

I always go back to the theme of Rabbit Hole. Which is "grief is a bitter pill that's swallowed, but with time it can change", so I just try to go after that. I just try to go with positive and negative is the character this way or that.

### How would you say your own gender influences your writing?

Whoa that's a big one. It affects it a lot, especially because I like to write for women. I like to have, because my opinion is that women have more societal struggles, I generally like to have them as my leads. I just root for them but as a man, it's a big obstacle. I have to ask; okay would a woman really say this?

### What are some authors that have influenced you?

Definitely Jim Morrison, T.S. Eliot always seems to find a way into a play of mine, but definitely Shakespeare. I mean I have to say that because really, during the process I always have to throw Hamlet. If my play was Hamlet, who is my Hamlet, who is Claudius. And John Patrick Shanley.

### How has your writing progressed within the class?

Yea, so when I talk about how I have a cluster-fuck of the characters words. When I first

started writing, I would just keep clustering, and it wouldn't be real, it wouldn't make sense. The class would force me to examine it.

It gave me structure and it gave me the ability to look at the plays more professionally. But yea, I've grown in the sense that I don't just cluster things together. I look at things more objectively now, and I don't care so much about the characters. I've learned to let them go and not care about so much. I've learned to take criticism.

### What is your reaction to having your work published?

It's very important. It's the pinnacle really. Because theatre is alive, and it changes every day, and it's not. It's nice to know that my words are going to stay the same. So it's huge. It's monumental. It's relieving to have say there it's published. I mean I've never had it but, I can imagine. And to know that everyone else can look at your.

### With this project, it's an exploration of expression. What drives you to write, what do you get out of it?

When Ray Charles talks about country music, he says "the stories that's why people love country music". I just want to create a story that nobody's made before. I have a really strong opinion about some true events that have happened in the past and I want people that don't know about this to be exposed to it, and for those who do know about it to see my point of view on it. I want the message to be clear.

I also spoke with playwright Desiree York:

**What's your own writing process like, when you sit down to write something?**

When I write, I feel like a fly on the wall, listening in on a conversation that I can see and hear in my head. I become the recorder and many times, the story is not in order.

**speak a bit about the words "Why are you shivering?" and what inspired you to offer those words, and what images or emotions do they evoke in you?**

Shivering makes me think of the cold. Because I am an emotionally driven person, cold leads me to loneliness and fear. The images evoked in me are ones of darkness and closed in walls. The words I offer are those of someone seeking hope and redemption.

**So lets talk about the excercises in class. Do you depend on them? Are they helpful?**

The exercises from the book are very helpful. They stimulate creativity and challenge my thought process.

**How would you say your own gender influences your writing?**

Social justice is at the core of my writing. As a female, my personal experiences bleed through in my writing as I strive to help others see what I see and hear what I

hear so that we can embrace and celebrate our differences.

### What other elements of life influence your writing?

As I mentioned before, all areas of social justice are at the heart of my writing. I long for a world where we can love each other as human beings and grow in the beauty of our diversity.

I also have a great love and passion for classical literature and specifically English literature.

### What are some authors that have influenced you?

The Bible, Elizabeth Von Arnim, Tolstoy, Jane Austen and Dickens

### What are your thoughts about having your own words published?

It gives me great joy to share my heart with others and I am humbled and honored by the opportunity.

### What drives you to write, what do you get out of it?

Writing is part of who I am - I must write. I've journal for over twenty years. And now stories and characters pop into my head with the simplest suggestion or seeing something beautiful or ugly and I record them. It is very therapeutic and gives me great joy to see characters come to life with a few scrawlings of a pencil.

Lastly, I spoke with fellow playwright Carlos Lopez, and here is some of his perspective:

**So lets talk about the excercises in class. Do you depend on them? Are they helpful?**

My writing sessions usually go one of two ways: I'll either hammer out several pages that I feel good about, or I'll type a little bit, then erase the whole thing, realizing it didn't work. In writing this piece, it was very much the latter, and on top of that, I was actually on a regimen to quit smoking. Finally, my mind kicked back on and I had my character's want. Then, after several different "what if" applications to that want, I came up with the monologue that ended up in this book.

**Since you were the person who originated the title for this project, speak a bit about the words "Why are you shivering?", and what inspired you to offer those words, and what images or emotions do they evoke in you?**

Shivering is one of those nice, unspecific symptoms that can inflict anyone and mean just about anything. We as human beings can shiver no matter what our emotional state, be it in anticipation of making love for the first time, joy at holding your newborn in your arms, despair of watching your loved one get laid to rest, or disgust at the teacher you thought you could trust. In short, a shiver implies a story that needs to be told.

**So lets talk about the excercises in class. Do you depend on them? Are they helpful?**

The exercises that Susan has us do in class are very helpful and relaxing. My problem, however, is that I very rarely use them. More often than not, I'm too focused how the project will finish than I should be on how to relax and reexamine what I have.

**How would you say your own gender influences your writing?**

Admittedly, most of my work tends to be very andocentric; most of my protagonists, antagonists, and characters in general are men, dealing with the world around them. That being said, what I really liked about this particular piece was that it was a man's perspective on something that has always been perceived as a women's issue. It's a story that's hardly ever told and very rarely listened to. It's an important story, and I hope that those who read it feel the same.

**What other elements of life influence your writing?**

That's one of the nice things about influence: it can come from just about anywhere. Politics, faith, social issues, pop culture, and occasionally random thoughts all have the potential to give me something I could use. But when it comes down to the root of the piece, it all depends on the effectiveness of the "What if…" that makes it interesting to write. The "What if…" for this piece that made me want to keep writing it was "What if he's afraid of what will happen after that last cigarette?"

**Who are some authors that have influenced you?**

My earliest influence, since I wanted to be a horror writer when I was younger, was and is, of course, Stephen King. As I got older, my list of influences only built up. As of now, they include Tennessee Williams, Eugene O'Neill, Martin McDonagh, Edgar Allen Poe, Hunter S. Thompson, and last but not least, Sam Shepard.

**With this project, it's an exploration of expression. What drives you to write, what do you get out of it?**

Every writer says that they want to tell a story, but I want my stories to give the readers and audience questions to ask. Questions about themselves, about their family, their friends, their enemies, their deities, and their truths. "Is everything just as they thought it was? Why or why not? What was there that wasn't before?" But the one question I want them all to ask, whether it be about my work, their lives, or whatever, is "what comes next?"

# WHY ARE YOU SHIVERING?

## Melissa Booey

I wasn't really accustomed to people like him. I mean he got in my face just about the second he met me. Doesn't anyone have consideration for another human being's personal space? You know, your box? Ugh. I should probably be careful saying that these days. Every man I complain to will think it's an invitation to try his hand at my vagina. Still, he impressed me with his words. And I don't mean lines, sayings or stupid fucking phrases I mean his words. A man who actually knew how to use his words. He pushed my buttons without even meaning to, and made me want to run and let him chase me without ever playing a game. I couldn't help myself though. Being the most typical version of myself was way too much fun. I couldn't just, allow this stranger to knock down every solidified wall I had bled and sweated over building for so many shrewish, icy, blessed years. Those were the days. Before I was pretty. Or no, maybe just before I stopped walking around like I was afraid someone might tell me I wasn't. That's when you can genuinely walk down the street without being shoved up on by some pedestrian bloodhound; when you want them

to see you. I savored my stronghold. My fortress. "Why are you shivering?" he asked me. "Because I'm cold," I told him. I lied.

## Spencer Derr

Why are you shivering? It's a question coming from the inner depths of my soul, from what right it is to be a man. It can be described in so many ways.
(pause)
Like the shivering feeling you get as you step out of a cold shower. My balls would literally roll up! It was so fucking satisfying! Shivering! No really, it was! The way it felt when you dried your balls with a warm towel and dug under them. I loved to scratch them clean. I shivered with pleasure when I did it. But that's the gist of it. There's just so much in life you take for granted. For one, my Dad took me for granted. And for two, I took my balls for granted.
(pause)
When I first felt those tender lumps, I was scared. I visited the doctor. He told me testicular cancer and I started shivering. He then proceeded to have the nerve to ask me, "Why are you shivering?" How could I reply back? I just shivered. I could have told him that what little chance I had of being a man was being taken away from me, but why? Why I asked myself? Why me? Why me?! I want to

be a man and teach my son how to piss in the toilet. I want to teach him how to play ball! I want to teach my son how to be a man like my father never did. You see…I know what shivering really means to me.
(pause)
I wanted to play ball with you Dad. You told me you'd come out and play with me. I stood there waiting for you to come out and you never did. The clouds darkened Dad; they darkened over the years you weren't in my life. You lost me in them. You left me there as it started to rain, as I started to shiver. You ripped my innocence away from me and I want it back. I want my chance back to be a man. I'll never forgive you for never being there for me. That's why when you told me years later to visit you, I didn't come. You didn't deserve to see me again.
(pause)
But the thing is Dad, I did come see you that night, that night you died…you just didn't see me. I came to the hospital room. I was looking from the door and I saw you lying there, shivering. I wondered…why? Why are you shivering? You had no right. You are the cause of my shiver, my eternal shiver! So don't you dare shiver in front of me! I left you

there, shivering. I left you shivering with the rain of your pulse dyeing down in my ears. I have bigger balls than you now, than you ever did. I don't need them to be a better man and I don't need you. I am my shiver.

## Quinn Sherman

No I'm not nervous, am I really shivering? No, it's just cold in here. I'm not nervous. May I sit here? (Sit) I'll stand (stand). Look, I know why you called me in the office. It's an idiotic and UNHOLY calamity that I would be blamed for what happened yesterday. Yikes that came out way more confrontational than the blueprints in my mind had intended. Let me start again. Redo (makes rewinding noises and gestures). I get blamed for a lot of things in the office and I'm tired and exhausted from people's accusations. They do it because they want to take my position, you must see that. I am a threat. I am a threatening person to weaklings. I'm confident, I'm attractive, I'm attracting and I can make a sale like no one else in this building. There's only room for one at the top and it's lonely, but it's worth it. Fools who attempt to grasp my position are quickly tossed back down to their rightful place. Now, I would never throw somebody under the bus or try to make myself sound better by demeaning others or leave hints in any way, …but it was Darla. It's all too obvious. Do you see the way she walks around the office?

Always looking for something, always smiling and laughing, always using her ear as a pencil holder; it just doesn't add up! So we could rot in this office while the real perpetrator of this heinous crime still lurks among us, or we could battle this bitch out. We could lock up every mother fucker in there until they starve. I will find them Sir. I will find out who ate your key lime pie and they will be demolished. I will devour them like a baby mouse in a hawks gaze. You can count on me (reaches out arm to shake). ...That's why I was called in, right?

## Natalie Besner

Because I'm cold. Duh. What kind of a question is that? I'm cold. Why else would I be shivering? (pause) Is that all you have to say to me? You know, we're sitting here together, and you can't even be interested in my day? Instead, I get (mocking) "Why are you shivering?" Jesus. Is it really that hard? To ask me about my day? Here. I'll help you out. Repeat after me: How—was—your—da—ay—to—da—ay? (pause) No? Still can't do it—even when I'm sitting in front of you, spelling it out. Oh! That's a good idea—I'll spell it out for you. (jots on napkin, tosses it) There you go. I've put it all down in black and white, spelled it all out for you. Now all you have to do is read it back to me. Read it. I know you can do at least that much. Still nada, huh?(genuine, wanting it to work) Well, what if I said it with you? We could say it together. (mostly joking—but not entirely) We could even hold hands. (reaches out) Nevermind. No need for theatrics, right? Count of three? 1…2…How was your day? (silence. Her face says it all) I am really interested, you know. In your day. In your life. I know I never really ask—well, except for right now, I never really

ask. Fuck!—This is hard. Ah—talking. To you, specifically. "You had me from ,,hello."" But what comes after? After "hello." Do you know when it got to be so hard? I don' t. Can' t remember. I can' t remember ever really talking to you. I can remember wanting to—and then not. I can remember thinking of all these remarkable, witty things to say or something would happen to me in a given day—something horrible or wonderful or even something really insignificant—and I' d want to tell you about it. So I' d have all these stories—these little tidbits—I' d store them all up in my head, planning to tell you when I got home. But I never really did. The timing always seemed off. The words never came out. Even now...the timing doesn' t seem right. The words—don' t seem right. Never really remarkable or witty enough. (questioning, unsure) Are these—the—right—words? I can' t really tell from your face. The thing is—these stories, these little tidbits—they' re my life, they' re me. And so, I guess then, you don' t know me at all. Not even a little bit. Everything after "hello" is a complete mystery to you. What am I supposed to do with that? How can we even begin to bridge that gap? All the unspoken

words… Because it's not like we're strangers. We're worse than strangers—we're people who have been living together without much more than an obligatory "hello" for as long as I can remember. (pause) You know, sometimes, I don't even know that you're home. The other day I was sitting in the green chair reading this really wonderful book—probably one of my favorite books ever—and I caught myself thinking, of course, that I had to tell you about this great book when you got home. And then all of a sudden, I got really lonely, and I just couldn't wait for you to get here. And at that exact moment, you walked down the stairs. You'd been here all along. I've never felt as lonely as I did right then.

## Grace Murphy

Trying" to. So.ber.up. AHHH! WOOH! YEAH! I'm good. I'm good. Oh, thank God, I'm back. WOW. I'm going to throw up. Seriously, I'm going to vomit. I'm disgusted. Yes, Hello, here I am! Holy shit, you are nasty, like…I'd rather wipe my ass with a pinecone than have sex with you. Again. No. Don't. Speak. Don't. Move. Don't ever speak again. I should have realized when my face went numb that something was wrong. Or when my jaw locked. Yeah…but sometimes that happens when I pretend to smile for too long, so that was a tough call because I didn't realize it was fake till…till I saw the black butterflies fall down dead. I usually see the black butterflies die right before I faint, but this time they woke me up, they woke me up and…to be honest, I was so sad…ha! I was sad… this was just another trip…I thought someone, maybe wanted to touch me, to actually touch me. That's just what you wanted right? Someone to touch you. I would have touched you. We could have touched each other. Maybe, I'd have liked that. People like us, we

should be touched more, don't you think?
Oh-The police are here.

## Robert Wallace

I can hardly remember the warmth of your smile. It would melt me. I can hardly remember the heat of your breath against my face. Do you remember what it was like when we were content to lie in the sun together watching the seconds crawl past, and debate over trivial things? We never could agree on which was more beautiful, sunrises or sunsets. I love sunrises, and you love sunsets. See, I know what sunsets bring. They bring silence, and the cold. I know those things all too well, and there's nothing romantic about them. Well you followed me into the sunset but the cold is choking you. I'm choking you. I'm sucking the breath right out of your lungs. You made the mistake of caring for me. I've made you want to be with me. But now you want so deeply, that the want has turned into a hunger that I can't satiate. I don't know how to be the person that you need anymore. I can't find the right formula-- the right combination of words that will tame the fears that overwhelm
you. I've forgotten how to feel anything else but the overwhelming guilt flooding over me like a snowy avalanche rushing over my entire

being. I'm frozen on the inside, I've always known that. I'm afraid that I've done the same to you. So now I have to stand here watching you shiver, and hope for the next sunrise.

# Marc Assad ( In verse)

Were you cold when it started, or did it come at you quick?

I've been there before myself, and unfortunately, I was stupid enough to stay.

I don't mean to tell you what to do, but really when last I stayed there, I got real sick.

I'm here; I can offer you an ear to listen, and beams of support, but at the end of the day,

The change is yours to make.

Why are you laughing at me now?

I only mean to still your shiver, but really, I'm just a passing vagabond.

And when I stumbled upon you in this place, I was taken back to when I shivered here.

I smile at my bright road ahead, but I stop in an effort to help, because our shivers create a bond.
So please, do not laugh in my face. It is a product of what shivers can create. So while you're here,

Answer me; will you listen to my effort to make you warm?

With your permission, can I help you stand?

Mr. Brooks called them strong, the ones who would dance in the flame.

Mr. Boyd, at the water's surface, beckoned me to experience the warmth, and forsake the cold below.

To them both and several others, I owe thanks. They stood, where I stand here, and called my name,

As I call yours now. They asked me to let them in, as I ask you now, will you accept a vagabonds help?

The choice was made by you, and you alone.

I don't know how it was, that you came to shiver, but we both know, the choice was yours.

To sit and find comfort in this shiver, is to drool over a heart that the self made bitter.

I don't mean to say that mine is the only way, or the only course.

But we share a bond, started by a shiver, a choice, and I see in you now, a desire to change your weather.

This world is dark and cruel, but just a little further down the river you'll see, this world is also giving.

So I ask you now, why do you shiver?

## David Royster

I'll tell you what I want. I want to cry. I want to crawl inside of my jacket and vanish. I want to disappear. I'm alone. And I know I must look miserable. Like it even matters anymore. The love of my life is on the edge of "I do" with some other guy and I can't even think of what I want to say to you. I object. Yeah, I totally object, but I haven't got a clue why. He's a good guy. Like a really good guy. After one day of hanging out he showed himself to be the coolest guy I've ever met. And I hate him because he's not me. My heart burns right through my chest. It's like chasing a carrot that I'll never reach. It's just held in front of me endlessly moving. I'd write you letters and then rip them up. I know you could never take them seriously. I couldn't give them to you for the same reason I couldn't say "I love you" two years ago. I don't… I don't trust me… I don't trust me to love you. It's some kind of torture. You're perfection, and me being, well, me, could never be what you deserve. I let that hold me back… And then all of a sudden I couldn't help it. I feel like I'm falling from the night sky. You're the only light I see. Wherever you are, no matter how

far I go, I end up seeing you somewhere, anywhere. Always checking back to see how you're doing. The air alone is suffocating, and I can't breathe without you Maggie. God, I'm shaking. I object because I have no choice… but to love you. I object because I'm on the edge. Because life without you is just… falling. Nowhere to land. No light, no air. And I've never asked myself what do I need, but the ground is coming fast and sooner or later you have to ask yourself before you hit it. Maggie, I needed to object, because you're everything I've ever wanted.

## Carlos Lopez

Goddamn it, I'm doing it again, aren't I? I must have looked inside this pack five times in the last ten minutes. I want one more, just for tonight. I've still got about ten left, so it's not like I can't. But I promised everybody that I was going to stay on this regimen. One cigarette a day for the next nine days and I'm done. But the fact is I'm scared of what will happen after that last cigarette.
I planned on having the last one on the anniversary. I thought it would be some kind of nice, symbolic tribute. It's been almost a full year already. If things had gone differently, she would have been about four months old now. I don't know why, but I'm almost certain that we would have had a girl. What would she have gotten from me? My eyes? My nose? I don't know. I never wanted this to happen. But what was I supposed to do? Tell her not to? Claim control over her body and her decision? Make her give up her life for the sake of a child that neither of us were ready for?
I shouldn't think about it. Every time I do, I feel guilty, and that's when I really shiver.

Not because I only get one cigarette, but because I know I'll start drinking again.
You know why recovering alcoholics shiver so easily? That lost liquor was what kept us warm. Not that it literally warmed us up; if anything, it lowers our body temperature. But we don't care. To us, it's warm. To us, it's safe. It protects us from the pain we've had before and whatever pain we expect to encounter. That's why a lot of us smoke. It provides at least a fraction of that protection we used to have. We crave that protection the way infants crave the safety of their blankets.
Infants. Babies.
I can't go back to that again. Drinking every night. Trying to escape the guilt. Thinking that, maybe, this is the night God will take pity on me and allow me to choke to death in my sleep. Hoping that my death will make up for my child's.
Okay. Maybe just one more smoke for the night. One more won't hurt.

## Desiree York

It wasn't because it was cold in the apartment that I was shivering. That tiny, claustrophobic box I called home. It was the darkness that hung in the air even when the lights were on. Reeking of despair. Hugging my knees so hard, wishing I was back in the womb. (beat) Alone. Yet crying out with every fiber of my being to the blank walls. Help me! I'm drowning and choking in and on my own tears. The pain doesn't stop. Just make it go away. Any way is fine. Draw the final curtain, I don't care anymore. Perhaps a toaster in the bathtub? A large dose of expired pills I saw earlier in the medicine cabinet? I could easily take a drive and accidentally crash into a tree. No one would care. Or would they? Do you care? You said you'd always be there – so where are you now? I can't read your book. All these blurry eyes can see anymore are failures and disappointments. I'll never be enough. You said light can't mix with the dark – well I'm here in the dark so how else do I get some light unless you come and turn it on? God, where are you? (Beat) And then I heard it. A soft whisper as if someone was lying next to me. It wasn't even what it said,

but how it as said. Begging - pleading me. "Please let me love you. I so want to be everything to you." And suddenly my body was encased in the warmth of an embrace. I could breathe. All was still. And I....I was free. I was no longer suffocating under my own bed pillow. He heard me. I don't have to DO anything. I'm enough. I can live, even in the darkness. Because I'm not alone. I know that now. And I want to live. Truly live. And now I know how. By just being me.

## Lora Miller

It's cold. I'm cold. I could be standing in front of the fire and still be freezing, my skin should look blue. Not from standing in the rain, not from the wind, but my heart doesn't feel warm anymore. The time signature of my heartbeat has altered. Its rhythm has fallen out of sync, out of the throbbing cadence our life-sustaining organs used to share. What was once a steady and fluid duet tumbled off into a lonely drum solo of the muscle that is supposed to pump the blood. To keep me warm. But it's not. I'm cold.

I don't want a blanket, I don't need any hot tea -- what I need is simply you. Any fragment of you. A touch, a whisper, something -- anything that will knock my heart back on track with yours. Your heart beats so fast, the blood flows so steadily through your veins. You blame it on the nerves. I attribute it to how big of a heart I know you hold within that chest. That chest that has a permanently imprinted outline of my head against it, where I used to lay and just listen to your heart pumping. It was almost as if I listened hard enough, clamped my eyes shut, I could practice with my own instrument to learn the

staccato tempo of your heart. But we never needed practice. We fell into each other, creating a symphony of not only beating hearts but breath. We inhaled the same air, tasted the familiarity of life together. Now my tongue feels charred and tasteless. I can't catch my breath. The only thing that seemed able to melt this premature frost is you. But now I see that things will never be the same. My heart will find a way to break its case of ice and learn to find warmth from within. My own hand clenched around it will guide the muscle to seek its own rhythm, its own opus. And maybe one day my glowing heart will gallop along with someone new. I can't live in this weather anymore. I want the tropics, the beach, the sun. Let me go. Or warm me up. But both of us, let's move into the sun.

## Katelyn Bailey

FRANK:
Really? You can't leave your house without your cell phone? Really? You're a fuckin' idiot, man. Kids, man. There are fuckin' 6 year olds with a cell phone. What do fuckin' kids need to do with a fuckin' cell phone? I have a cell phone, man, you know what it does? It gets and sends phone calls and texts. No apps and all that bullshit. Kids are spoiled these days. You should see some of the shit holes I've seen, then you'll realize how good you have it. People are spoiled, man. You go somewhere else and see how bad they have it. Then you'll know how well off you are. (Pause)....Arizona in the Spring time is nice man, huh? Haha, don't want to be there in the Summer. I remember at Camp Victory sometime it was 119 degrees. 119, dude. I mean fuck. Afghanistan's not so bad. Iraq's really fuckin' hot. And the poppies. Hills just full of them. Why don't they just napalm the shit and that will solve their problem. But they won't. They're all fighting their own and picking each other off. They claim their God fighters man, they're full of shit, they're selling drugs. You'd lose your mind thinking about it, man. That's

why my ipod has 9000 songs on it. Going on itunes gave me something to do the 3 times I was out there. There aren't any women. (Pause) When I joined, I thought the infantry was so cool and badass, but now I know that it's just testosterone, you know? It's a badass testosterone den, dude, and you just do your thing and whatever.

## Harris Ahmed

Because I am alone. I don't feel anymore. The thoughts the feelings crumbled inside my mind don't make sense. I want to journey far away hopefully to find a thought, pure , and healthy. But I am here alone, unaware of my next moves. Contemplating if happiness can truly exist in the mind of a human being. Or were we evolved to worry, to feel, to hate, and ponder unnecessary and horrible acts. Murder is rampant. Sex is no longer meaningful. I shiver because I feel the world toppling into the the dark abyss. I wonder if they'll ever be a cure to lonely nights, sleeping away the pain and reality of life. Won't somebody come and wrap up in warm blanket. Say, everything will be alright. No need to worry, money is not what you need. Love and peace contain all the answers. But until then, I will shiver, so as to let people know I am not alright. I don't feel okay. The question is not why I shiver; it is why no one else does, when all around us chaos exists.

ACKNOWELEDGMENTS

INTRODUCTION. Copyright © Susan Merson. All rights reserved.

MONOLOGUE. Copyright © 2012 Melissa Booey. All rights reserved.

MONOLOGUE. Copyright © 2012 Spencer Derr. All rights reserved.

MONOLOGUE. Copyright © 2012 Quinn Sherman. All rights reserved.

MONOLOGUE. Copyright © 2012 Natalie Besner. All rights reserved.

MONOLOGUE. Copyright © 2012 Grace Murphey All rights reserved.

MONOLOGUE. Copyright © 2012 Robert Wallace. All rights reserved

MONOLOGUE. Copyright © Marc Assad. All rights reserved.

MONOLOGUE. Copyright © David Royster. All rights reserved.

MONOLOGUE. Copyright © Carlos Lopez. All rights reserved.

MONOLOGUE. Copyright © Desiree York. All rights reserved.

MONOLOGUE. Copyright © Lora Miller. All rights reserved.

MONOLOGUE. Copyright © Katelyn Bailey. All rights reserved.

MONOLOGUE. Copyright © Harris Ahmed. All rights reserved.

www.ingramcontent.com/pod-product-compliance
Lightning Source LLC
Chambersburg PA
CBHW072252170526
45158CB00003BA/1058